June 29,
2008

from the
Washington D.C.

National Gallery of Art

(with Neal, Diana, & Karla; & cousins Nancy & Joe Foster)

Weekends with the Impressionists

For M.R. and I.H. McKinney

Front cover: Henri de Toulouse-Lautrec, *Marcelle Lender*
Dancing the Bolero in "Chilpéric" (detail), 1895–1896
Back cover: Mary Cassatt, *The Loge* (detail), 1882
Endpapers: *Paris and Environs*, Karl Baedeker, 1904
Page 4: Claude Monet, *The Artist's Garden at Vétheuil* (detail), 1880
Page 6: Edgar Degas, *Four Dancers* (detail), c. 1899

First published in the United States of America in 1997
by UNIVERSE PUBLISHING
A Division of Rizzoli International Publications, Inc.
300 Park Avenue South
New York, NY 10010
www.rizzoliusa.com
Copyright © 1997 Universe Publishing

ISBN: 0-7893-0111-3
Printed in China
Library of Congress Catalog Control Number: 97-61194
Design and typography by Russell Hassell

Weekends with the Impressionists

A Collection from the

National Gallery of Art, Washington

by Carla Brenner

UNIVERSE PUBLISHING

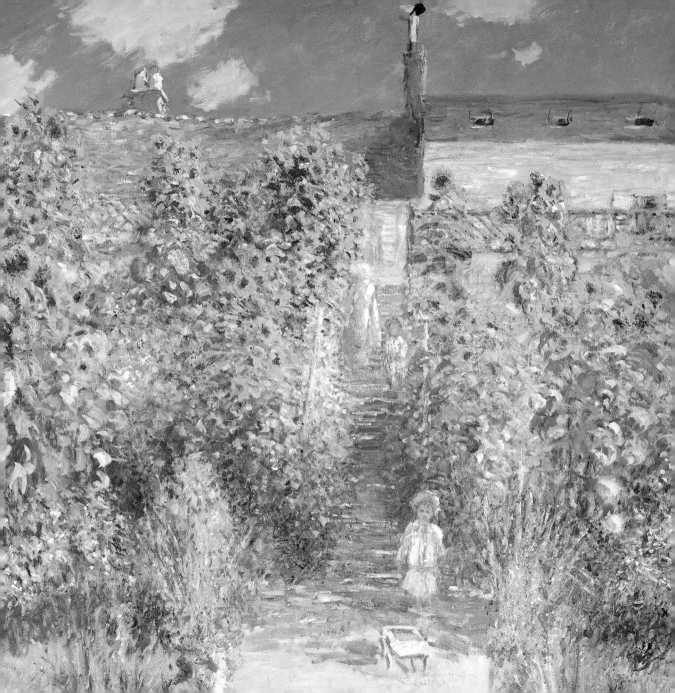

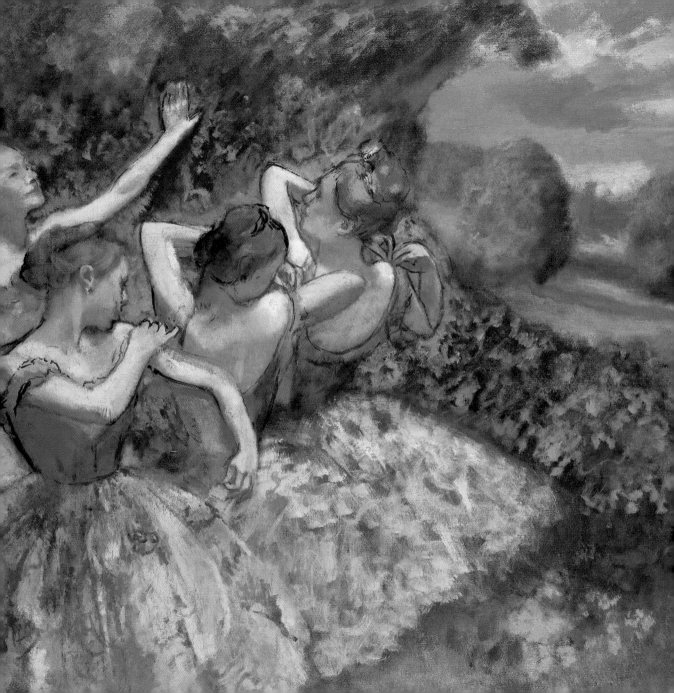

Foreword

The paintings of the impressionists are filled with weekends, with times of pleasure and delight. Our own notions of leisure—of what a weekend should be—have been colored by these images of *joie de vivre*. They are paintings fresh with the air of grassy meadows and bright with the sun, or scented with the tang of a seaside holiday. They capture the relaxation and simple joy of young couples boating on the river or picnicking along its banks, the sheer delight of sitting among flowers. They record the pleasures of children playing in crisp city parks, of people at the racetrack or in museum galleries, of busy pedestrians on the street. And they mirror the gaslit entertainments of Parisian nighttime: the gleam of silk-clad theater audiences, diaphanous clouds of ballet dancers moving on stage, young men at a dress ball, their top hats split by glossy reflections. ❧ Behind all these amusements rests a universal enthusiasm for living. At the end of the nineteenth century, the French saw themselves as more capable of enjoyment than any other people on earth, better equipped with amusements, and more demanding of them. Even though it was not until 1906 that France guaranteed its citizens even one day off per week, there were unprecedented possibilities for leisure, enjoyed by all people. "Weekends"—sophisticated evenings in town or afternoon idylls in the suburbs—were a part of the world impressionist artists saw and painted. Their weekends captivate and enchant us still. ❧

Your city, O Paris, is the world. —H. DERVILLE, *Paris nouveau*

Days and Nights in Town

No other city has been pictured the way the impressionists painted Paris—they captured it alive. Other places have been immortalized, their streets and monuments painted with topographical detail, their panoramas and curiosities recorded. But these impressionist views of Paris are different: they are not so much cityscapes or even portraits of Parisians as they are moments in the life of the urban experience. 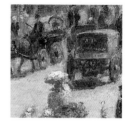 Paris was a busy place, the "capital of the nineteenth century," in one historian's view, where industry, commerce, and culture were concentrated. The city's twisted, narrow past had been literally straightened and widened, as its medieval neighborhoods were modernized. Large-scale renovations

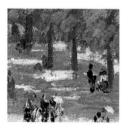 undertaken by the urban planner Baron Haussmann created the broad, tree-lined avenues we know today—bustling arteries filled with carriages, cabs, and omnibuses. Sidewalk kiosks informed pedestrians of theater openings. Displays glittering through large plate-glass windows lured people to exclusive shops and new department stores. In late afternoon, when fashionable society went on promenade, the avenues became an endlessly varied spectacle, best viewed from a café chair. Cafés and conversation—they have been called Paris' "supreme merit"—were midwives in a way to the very birth of impressionism. It was at the

Café Guerbois and later in the Café de la Nouvelle-Athènes 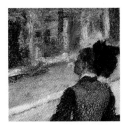 that young avant-garde artists Manet, Monet, Renoir, and others met to discuss their new approach to painting. Cafés were not new to Paris, but their number and importance was. An official count found 30,000 cafés in the 1880s, more than ten times the number per capita in London. They ranged from the most opulent to the most basic of working-class establishments. Because renovations had left the city short of housing, the café was an extension of domestic space for many citizens. In

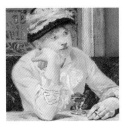

neighborhood cafés, Parisians ate and drank, courted their spouses, debated politics with their friends. ⬧ And cafés were far from the city's only attraction—guidebooks were filled with diversions to delight tourists and Parisians alike. For students of art and history, there were the vast galleries of the Louvre to

explore. Days could also be spent at the city's parks. The largest of these was the Bois de Boulogne, on the western edge of Paris. Within its 2,000- plus acres were wooded glades for picnicking, wide *allées* for carriage rides, and a man-made lake where one could drift in a Venetian gondola. There was a zoo and botanical garden, a skating rink, and the famous Longchamps racecourse. ⬧

Thousands of newly installed gaslights extended Paris' pleasures into the night. At café-concerts, singers, comedians, and acrobats performed, outdoors when the weather was good. An almost insatiable desire for novelty produced a staggering 14,000 new popular songs each year, featuring such lyrics as these from "Viens poupoule":

Saturday evening, after work
The Parisian worker
Says to his woman: for dessert
I'll treat you to the café-concert
Arm in arm, we'll slip up
To the twenty-sou balconies
Put on a dress quickly, we must hurry . . .

Working-class Paris might go out only on a Saturday night, but wealthy society, *le tout Paris*, had a regular schedule of amusements. Tuesdays it was the Comédie-Française, Fridays the Nouveau Cirque, and other nights it was music and refreshment in the park-like setting of the Ambassadeurs, a favorite café-concert of Degas. On the hill of Montmartre, windmills contributed to the

 picturesque settings of music and dancehalls. The old mills at the Moulin de la Galette had been used to grind iris bulbs for perfume, but at the more famous and more expensive Moulin Rouge the mill was never more than a prop, merely an elaborate decoration. Audiences were a diverse lot, workers and shopgirls mingling with elegant couples to see dancers of the notorious can-can. ❧ Nearly half a million people went to the theater each week. Watching fare that ranged from Racine to the risqué, theater-goers also cast a curious eye around the seats and balcony boxes: new fashions, rich men and their mistresses, proper young ladies with exaggerated decorum—all were equally part of the evening's entertainment. Among the city's most expensive tickets were those to the Opéra. When the old opera burned, expense was lavished on an opulent new building that anchored the *grands boulevards*. Its stage, the largest in the world when it opened, was

home to comic operetta as well as more serious productions, often with ballet interludes to entertain between acts. ❧ The impressionists found subjects in all these in-town pleasures, among the park-goers and promenading public, among audiences and performers alike. Their images, whether of sunlit streets or crowded nighttime bars, reflect the energy of Paris, the nineteenth century's most sophisticated city. ❧

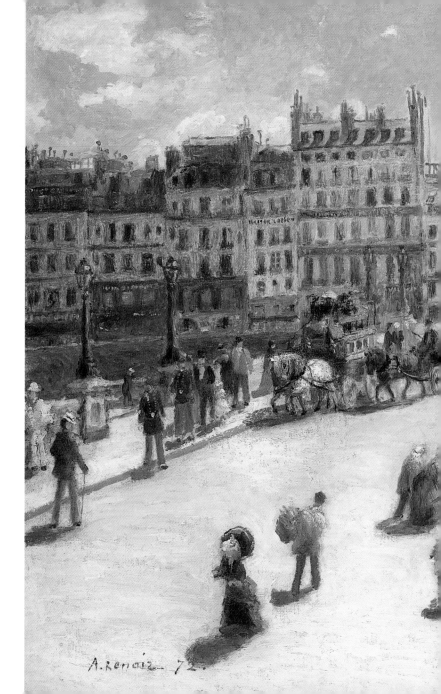

> *He determined to paint*
> *blazing sunshine,*
> *the blazing sunshine*
> *peculiar to Paris . . .*
>
> —EMILE ZOLA, *L'Oeuvre*

AUGUSTE RENOIR
Pont Neuf, Paris (detail), 1872

Renoir's Pont Neuf vibrates with light, its yellow pavement brighter even than the sky. The bridge is crowded with soldiers and dandies, laborers, and elegant young women. One man, in a straw boater and carrying the cane of a fashionable *boulevardier*, appears twice. He is the artist's brother Edmond, sent to delay these busy Parisians with idle questions so that Renoir—working at a window nearby—could paint them as they paused to answer.

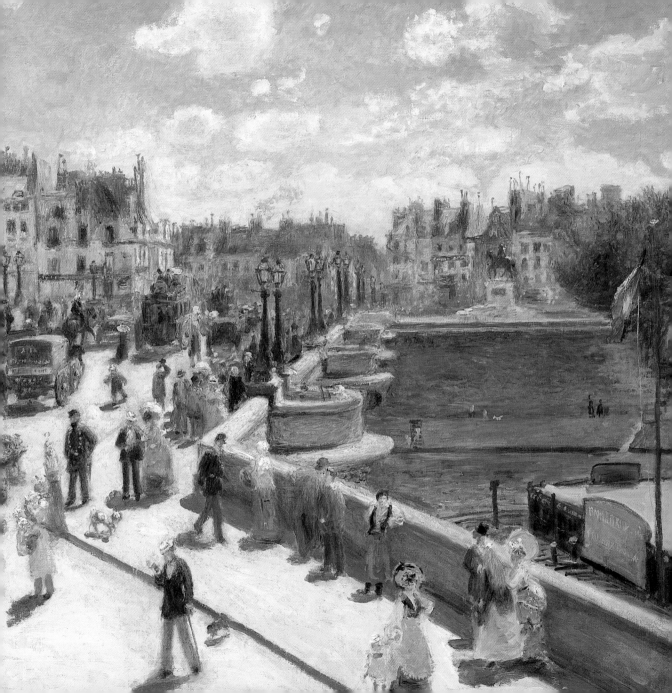

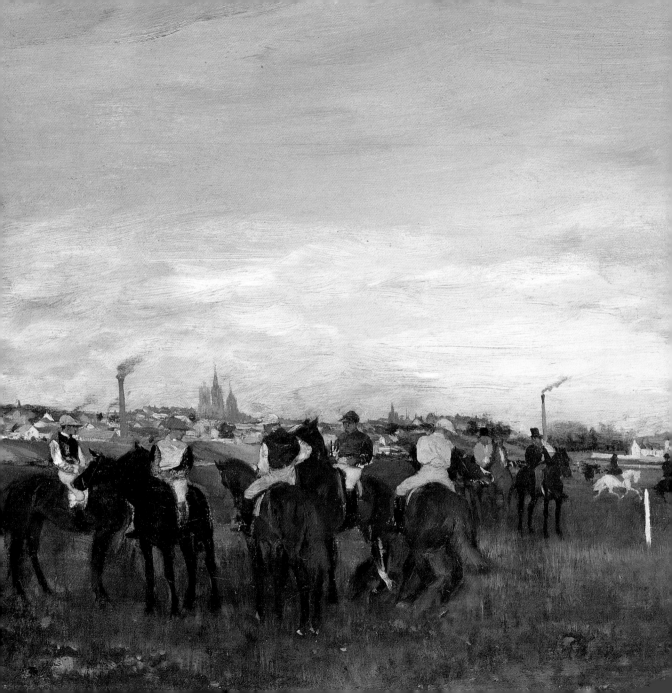

The horses came onto the course one by one, led by stable boys, with the jockeys in the saddle, arms relaxed, the sunlight making them look like bright patches of color.

—EMILE ZOLA, *Nana*

EDGAR DEGAS

The Races (detail), before 1873

Horse racing attracted many well-to-do Parisians, including Degas, who was a frequent spectator in the stands at Longchamps. Admission to the lawn, the *pelouse*, cost only one franc. Sunday races thus became a popular family outing for those of more modest means—especially after a pari-mutuel system was introduced that gave even small bettors a chance for winnings.

In the garden of the Tuileries he
had lingered. . . . He watched
little brisk figures, figures whose
movement was as the tick of the
great Paris clock, take their
smooth diagonal from point to
point; the air had something
mixed with art . . .

—HENRY JAMES, *The Ambassadors*

CAMILLE PISSARRO
Place du Carrousel, Paris (detail), 1900

Tiny shapes, dark-coated men and women with
parasols, children in hand, move with different
rhythms. Across the Tuileries toward the place du
Carrousel and Louvre, a few appear to stride, but
more seem to stroll or stop in the long shadows,
enjoying the light and air, the freedom and refuge
of open space.

18

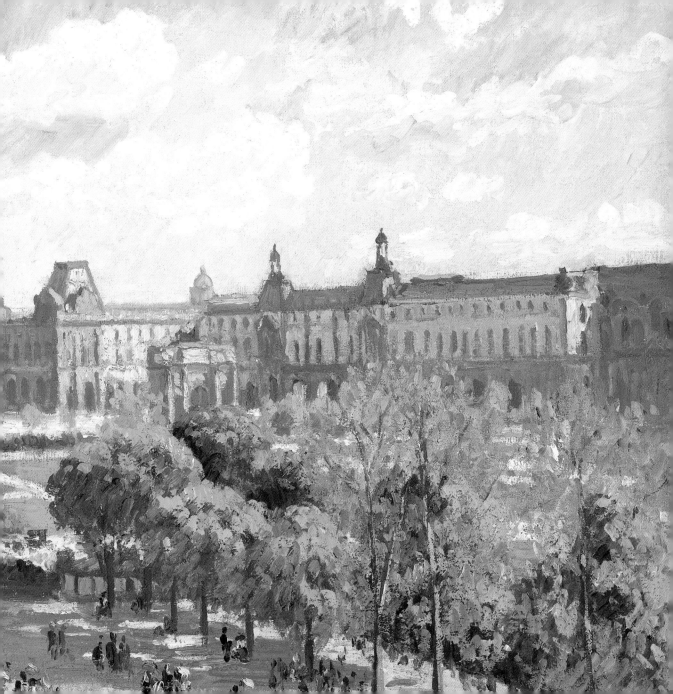

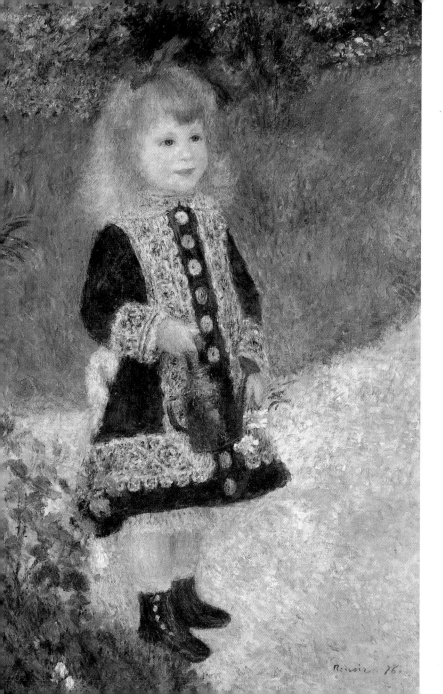

...she had halted

abruptly, with her

watering can in her hand...

—GUSTAVE FLAUBERT

Sentimental Education

AUGUSTE RENOIR
A Girl with a Watering Can (detail), 1876

A charming girl, in a charming dress, stands with a tiny watering can and a stolen bouquet. Perhaps these flowers and the pebble path—a mosaic of colors—were in a public garden near Renoir's studio in Montmartre. Suffering financially in the years immediately following the first impressionist exhibition, he painted a number of such engaging pictures in the hopes of winning sales and portrait commissions.

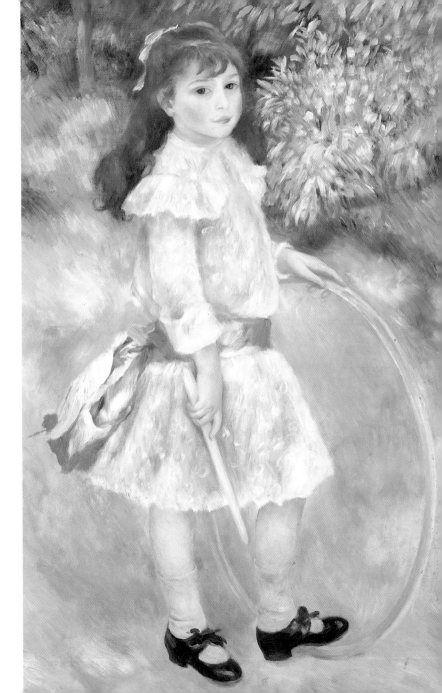

AUGUSTE RENOIR
Girl with a Hoop (detail), 1885

For hoops and other games, the
carefully tended paths and squares
of public gardens provided the
perfect arena. Manet, for one, was
said to visit the Tuileries every
afternoon to sketch children at play
and their nurses chatting under the
shade of chestnut trees. This girl is
Marie Goujon; her portrait is one
of a set Renoir painted of the four
Goujon children.

They went non-stop through all the rooms one
after the other, their eyes dazzled by all the gold in the frames,
seeing the pictures going past—far too many of them to be
taken in . . . what a lot of pictures, they went on forever!

—EMILE ZOLA, *L'Assommoir*

EDGAR DEGAS
Woman Viewed from Behind (detail)

Sketchy suggestions of gold frames and pink columns place
us in the long Grande Galerie of the Louvre. For many
Parisians, a trip to the Louvre was a Palm Sunday tradition.
This woman, however, was probably a more frequent visitor.
In all likelihood, she is American artist Mary Cassatt, a
friend and collaborator of Degas. The two first met in the
Louvre. The official Salon exhibitions also drew large
crowds every year. The mad crush of "varnishing day," just
prior to the formal opening, was a social occasion that
attracted *le tout Paris*—art lovers or not.

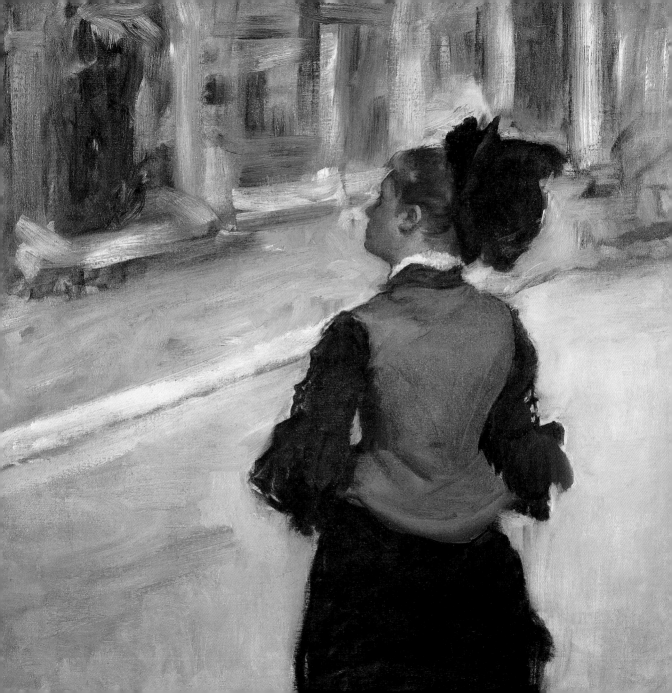

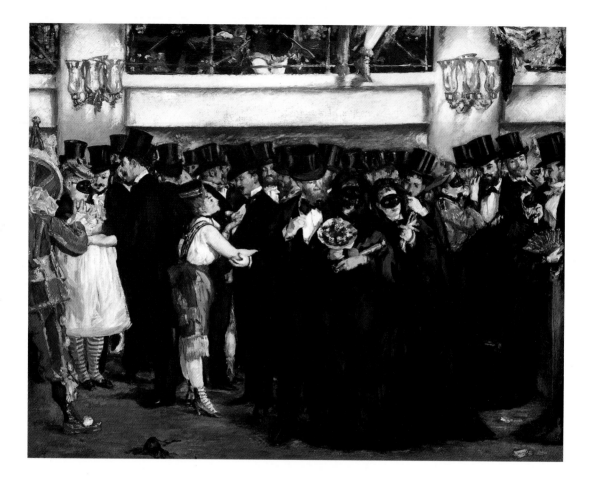

. . . the opera house packed to the rafters, the boxes
furnished out with all the pretty showgirls of Paris, the lobby filled
with charming ladies in charming costume.

—*Le Figaro*, 1 April 1873

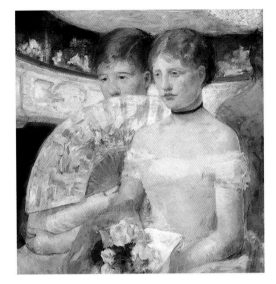

MARY CASSATT

The Loge (detail), 1882

Not all the display at the theater occurred on stage, and these young women are here to see and be seen. Probably they are Mary Elliot, a friend of Cassatt's visiting from Philadelphia, and poet Stéphane Mallarmé's daughter Genéviève. Although it first appears that they are sitting in orchestra seats at an elegant theater, the rows of balconies behind them are actually reflections from the mirrored wall of their box. Ladies were not permitted orchestra seats.

Left:

EDOUARD MANET

Ball at the Opera, 1873

The doors opened at midnight on the masked balls held Saturdays in the old opera house on rue le Peletier. These were public dances. Anyone with the price of admission could attend. The crowd—described by one tourist guide as "boisterous and not well behaved"—included rich young men, society ladies incognito behind their masks, and scantily clad demimondaines, actresses, and dancers. The panorama of formal attire and fancy dress provided Manet a palette of silky blacks and brilliant color.

In one of the boxes a bare shoulder gleamed like snowy silk. Other women sat languidly fanning themselves, following with their gaze the movements of the crowd.

—EMILE ZOLA, *Nana*

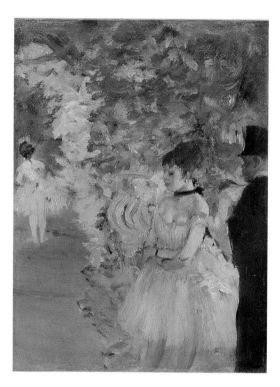

EDGAR DEGAS
Dancers Backstage, 1876/1883

"Sponsorship" of young dancers by wealthy men was a fact of life. Subscribers, like the top-hatted *abonné* in Degas' picture, had free access to dressing rooms and the wings backstage. Ballet interludes at the opera were even timed so that a gentleman could dine with his mistress before her performance. As long as some discretion was maintained, such liaisons were considered quite normal, tolerated by society and ignored, publicly at least, by wives.

Right:
AUGUSTE RENOIR
The Dancer, 1874

An enigmatic expression, a bit wistful, a bit knowing. This reviewer, who encountered Renoir's picture at the first impressionist exhibition in 1874, saw beyond the gauzy costume and the airy lightness of Renoir's paint to the hard demands ballet put on childhood. Girls, almost all from poor families, began classes at age seven or eight and worked long hours. A teenage dancer, if she succeeded in becoming a *corphée*, probably earned more than her father. But in the 1880s, fame and aristocratic marriages achieved by some leading dancers also began to attract girls from middle-class families.

Still a child?
Doubtless. Already
a woman?
Perhaps.
A young girl?
Never.

—JEAN PROVAIRE

in *Le Rappel*, 20 April 1874

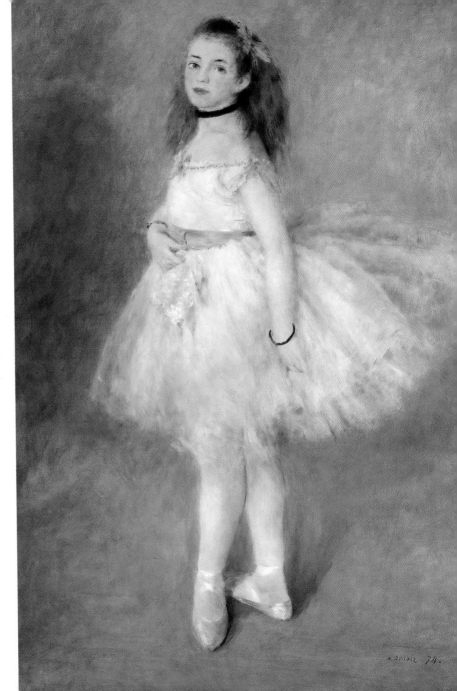

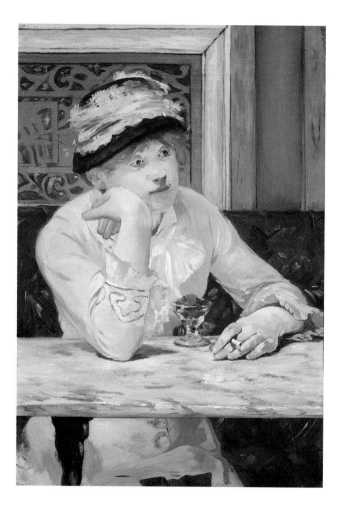

EDOUARD MANET
The Plum, c. 1877

Who is this sitting pensive and alone at a café table? A brandied plum remains untouched, her cigarette unlit. Maybe she is a prostitute. Proper ladies did not smoke in public, and "nymphs of the *pavé*" often met their trade in bars. But given her demeanor and her demure pink dress, modest and maybe a little more expensive than she can afford, it is more likely she is a shopgirl, a *grisette,* who awaits or perhaps only dreams of a friend or lover.

Right:
HENRI DE TOULOUSE-LAUTREC
Quadrille at the Moulin Rouge, 1892

The *danseuse* Gabrielle, hands on hips, is poised to begin the *quadrille naturaliste,* one of the riotous dances foreigners called the can-can. A flounce of petticoat glimpsed behind her is evidence of its high kicks. At the Moulin Rouge, performers were not separated from the audience on a stage, but danced in the midst of top-hatted men and fashionable ladies.

Twenty sets formed, the music struck up, and then—I placed my hands before my face for very shame. But I looked through my fingers. They were dancing the renowned Can-can.

—MARK TWAIN, *Innocents Abroad*

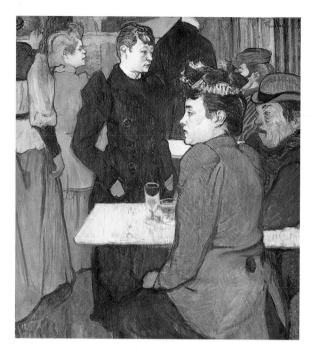

HENRI DE TOULOUSE-LAUTREC
A Corner of the Moulin de la Galette, 1892

Nights in Paris were times of sociability but also of remoteness. The strange silence of Toulouse-Lautrec's picture captures the emotional isolation of prostitutes, dancers, and drinkers dulled by absinthe. The wormwood liqueur absinthe, outlawed early in this century, was cheap and plentiful. At ten to twenty centimes a glass, it was half the price of wine—and twice as dangerous. "A terrible and frightening drink," cautioned one nineteenth-century writer.

. . . from this showy tinsel, he will feel a vague and desperate optimism emerging, all enveloped by a delicate and tired ennui, pressing the temples gently like a caress.

—JEAN DE TINAN in *Mercure de France,* November 1897

Right:
HENRI DE TOULOUSE-LAUTREC
Marcelle Lender Dancing the Bolero in "Chilpéric," 1895–1896

Appearing at the Théâtre des Variétés in the comic opera *Chilpéric,* Marcelle Lender, with red hair and pink ruffle, seemed almost ablaze in the vaporous green lighting. In 1882 the Variétés became the first Parisian theater to use electricity. The new lights produced dramatic effects, but perhaps their greatest advantage was to allow theater managers to dim the house, keeping the attention of audience members focused on the stage instead of on each other.

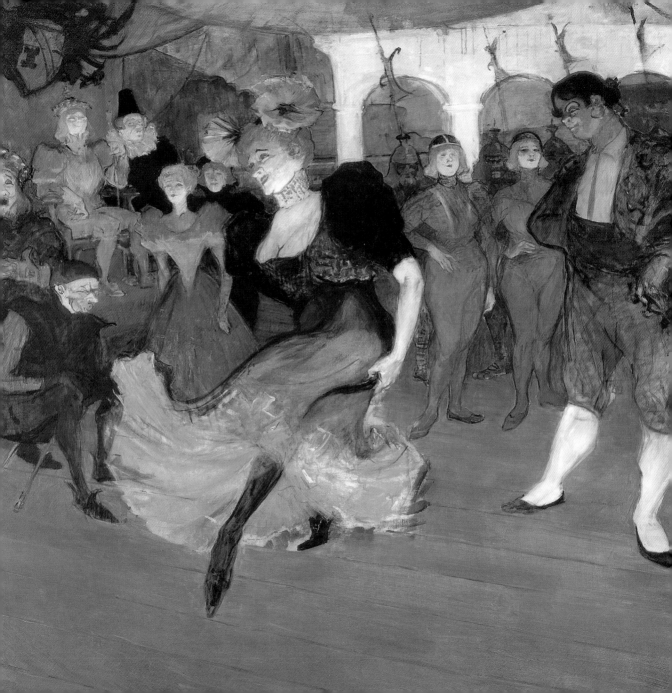

Painting and the joy of seeing flowers, this is enough for my happiness. —CLAUDE MONET

Outdoors in Gardens and the Countryside

*W*orking in the sunlight. This is our image of the impressionist artist— standing before the easel in a flower-strewn meadow, white hat shading the eyes. When asked about his studio, Monet went so far as to exclaim, "Studio, but I never had one!" and flung his arms wide to embrace the whole out-of-doors. "That," he said, "is my studio." ❧ It wasn't true of course. He did have a studio, and used it. Still, *plein-air* painting—painting in the open air—was a kind of touchstone for the

impressionists. By working quickly and directly, right in front of their subjects, they sought to record an immediate visual sensation. Their true subject was a fleeting effect of light and atmosphere—and they found it in gardens and quiet corners of the countryside. The most picturesque spots, it seemed, were also the most inaccessible, and there was the discomfort of rain, high winds, and

insects—still, it is hard to escape the conclusion that for the impressionists, painting *en plein air* was itself a pleasure to be enjoyed. Certainly, many amateur artists followed them to the countryside, with fully outfitted painting kits strapped to their backs. ❧ Artists were not alone in turning to the out-of-doors.

As France became more industrialized in the late nineteenth century, the beauties of nature held ever greater romantic appeal. There is evidence of this in the number,

 and less formal style, of new parks and public gardens in Paris. Areas of the sprawling Bois de Boulogne, for example, were designed with built-up hills, artfully curving woodland paths, and cement-lined lakes—a thoroughly artificial "natural" environment. More than 400,000 new trees were planted there. Similarly, a taste for *le jardin anglais* brought the tumbling profusion of English cottage gardens to private homes in Paris. ❦ Small towns along the Seine, only a few kilometers and several railstops from the city, attracted Parisian day-trippers. They came, particularly on Sundays, to stroll in meadows, pick flowers, and picnic in a pleasant spot. In many of these towns, local caterers could 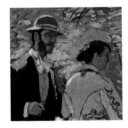 provide the necessary provisions for an elegant luncheon on the grass: food and drink, linen and silver, even a server who would remain discreetly in the background. The custom of picnicking had evolved first from the hunt breakfasts of aristocrats; 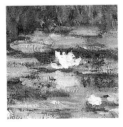 now it was a pleasure anyone could enjoy. Up and down the river, there were also outdoor restaurants and boating establishments that featured dancing and other entertainment. ❦ Many of the artists we associate with impressionism left Paris for smaller suburban towns. Generally, these towns were

cheaper places to live, and good rail connections meant painters could still reach dealers and suppliers in Paris—Argenteuil, for example, was less than a half-hour

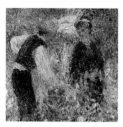

from the Gare Saint-Lazare. Most important, it was in these villages and their surrounding countryside that artists like Monet, Renoir, Sisley, and Pissarro found the subjects they most wanted to paint. Pontoise, Argenteuil, Bougival, Louveciennes: their names, like their river

banks, their streets and bridges, even their smokestacks and church towers, are familiar to us from the early paintings of the impressionists. ❧ It was not raw nature, the dense wooded wildness of the forest, or even the regular rhythms of agriculture that captured their imagination. With few exceptions, they painted a suburban world, a world of graceful living, not rural life. Following expansion of the railroad into these small villages, had come industry, speculators, and middle-class

Parisians. Farm property was converted to factories and suburban villas, vegetable plots to industrial yards and flowerbeds. It is hard for us to imagine these villages without flowers, but farmers had wasted little time on crops that did not pay. Now, though, a house and fine garden helped middle-class

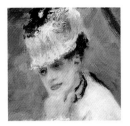

residents identify with wealth, royal gardens, and aristocratic tastes. ❧ Several of the impressionists were themselves dedicated gardeners, Monet most famously. He surrounded a succession of rented houses, in Argenteuil and later at Vétheuil, with lavish plantings. If he sometimes left his landlords with unpaid bills, he also gave them gardens to enjoy. In 1883 he moved to Giverny, to a property he eventually bought, and set about designing his most ambitious garden. Its yearlong procession of color and the floating world in its lilypond became the painter's only subject. More than a studio, it was a kind of art:

> *The garden itself is a true transposition of art, rather than a*
> *model for a painting, for its composition is there in nature itself*
> *and comes to life through the eyes of a great painter.*
> — MARCEL PROUST, *Le Figaro*, 15 June 1907

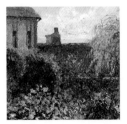

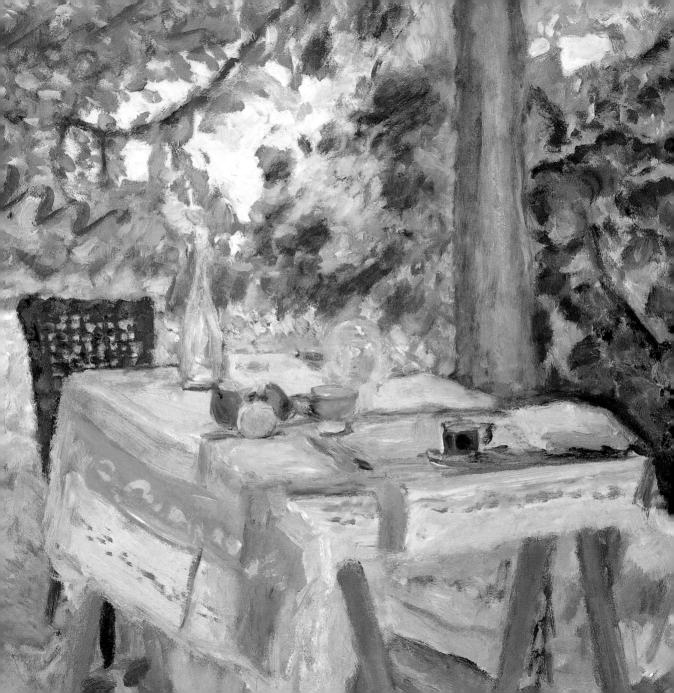

Left:
PIERRE BONNARD
Table Set in a Garden (detail), c. 1908

CLAUDE MONET
Bazille and Camille
(Study for "Déjeuner sur l'Herbe"), 1865

A couple pauses in the dappled light of a clearing. They seem to have stopped only momentarily, but what they were approaching is unseen. In fact, it was a cloth and picnic spread on the forest floor, along with other elegantly dressed young couples. We know because this is a partial study for Monet's *Déjeuner sur l'Herbe (Luncheon on the Grass)*, a huge painting, twenty feet wide, of the artist's friends on an outing to the Fontainebleau Forest. There they lounged under the trees, enjoying food, wine, and conversation.

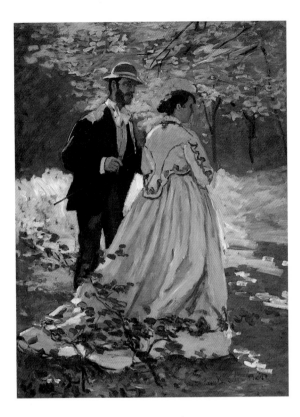

It was a lovely day, the sort of day that sets your heart racing. Even now, a fine day makes me lightheaded . . . like champagne when you aren't used to it.

—GUY DE MAUPASSANT, "In the Woods"

CLAUDE MONET

The Artist's Garden in Argenteuil
(A Corner of the Garden with Dahlias) (detail), 1873

"In no other era have flowers and plants been so widely appreciated." Such was the judgment of one of the many new gardening manuals and journals that proliferated in France during the late 1800s. There were more amateur gardeners than ever before, and a huge market for commercially grown flowers as well. In Monet's garden at Argenteuil a hedge of dahlias—Monet loved the bi-colored varieties—spills over with seeming artlessness. However, like all great gardeners, Monet planned the colors and textures of his plants very carefully to harmonize throughout the year.

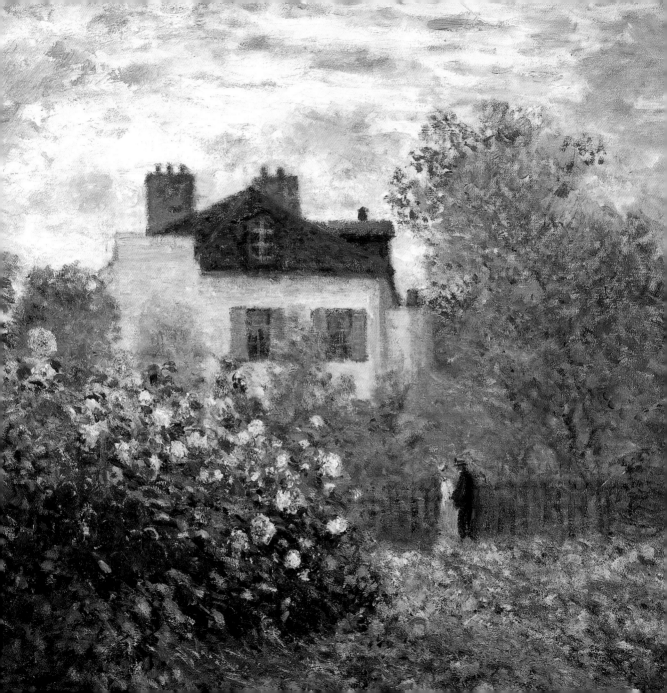

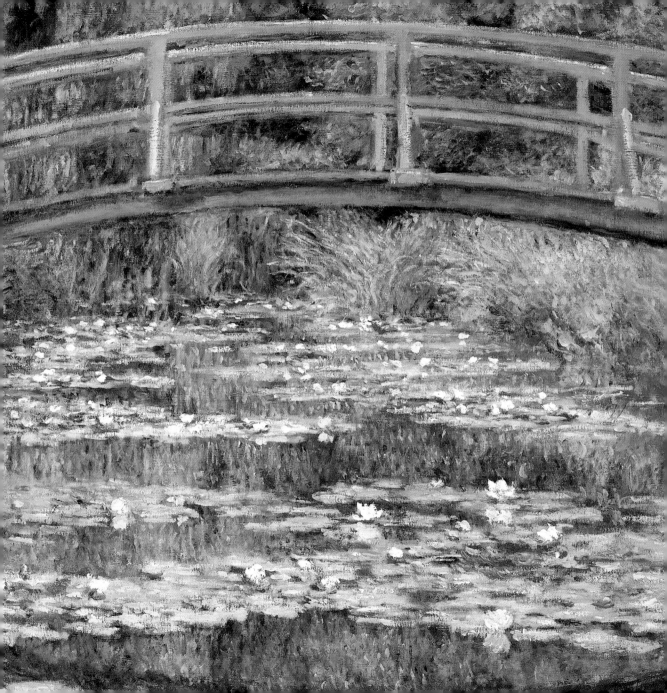

. . . he converted a patch of landscape, and filled it with water to mirror the sky, and with plants: some red, yellow, pink, and white waterlilies to float on this water as though on the surface of the sky . . .

—JEAN-PIERRE HOSCHEDE, *Monet, ce mal connu*

CLAUDE MONET

The Japanese Footbridge (detail), 1899

Monet diverted river water to create his aquatic garden at Giverny, shaping the land with as much artifice as his painting. In the last decades of his life, he painted little except this footbridge and his prized lilypond. "It took me some time to understand my water lilies," Monet said. "I planted them for pleasure" Eventually his canvases were devoted solely to the pink and white floating shapes of lilies and their reflections. Monet had always been fascinated by reflections, believing their watery patches were like his own broken brushwork.

Yes, we have decided for Eragny on the Epte. The house is wonderful and not too dear: a thousand francs with garden and fields.

—CAMILLE PISSARRO

CAMILLE PISSARRO
The Artist's Garden at Eragny (detail), 1898

Pissarro's garden reflects the country gardens of an earlier time. Before such towns as Eragny attracted new, middle-class residents from the city, their gardens were agricultural—plots for vegetables, farm animals, and fruit trees, not flowers. Pissarro planted and painted both flowers and carefully tended vegetable rows. The artist, one contemporary reviewer complained, "has a deplorable liking for truck gardens and does not shrink from any presentation of cabbages"

CAMILLE PISSARRO
Peasant Girl with a Straw Hat, 1881

Rustic people and rural life were not of much interest to most impressionist artists, who preferred instead to paint fashionable Parisian couples on country outings. Only Pissarro painted peasants at work in the fields or resting after their tasks. Committed to socialist principles, he did not sentimentalize them but saw their labors as honest and free of bourgeois artificiality.

Left:
ALFRED SISLEY
The Road in the Woods (detail), 1879

Sisley never abandoned the principles of impressionism. While Monet became preoccupied with the painted surface and labored over his canvases in the studio, Renoir sought to reproduce an enduring, classical art, and even Pissarro experimented with pointillism, Sisley alone continued to paint pictures such as this, spontaneous records of his experience in nature.

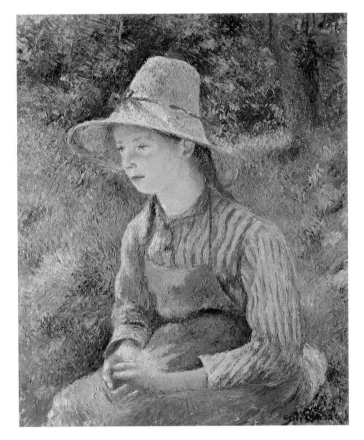

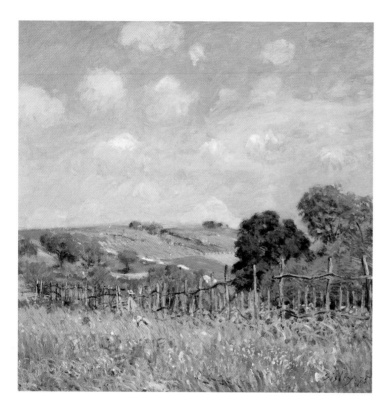

ALFRED SISLEY
Meadow (detail), 1875

Right:
AUGUSTE RENOIR
Picking Flowers (detail), 1875

Even in his landscape pictures, Renoir was more interested in the men and women he found delighting in the countryside than in the countryside itself. He painted their youth and charm, their obvious enjoyment of a flower-rich place. For Renoir, the most pleasant stroll always included a companion.

Every picture shows a spot where the artist has fallen in love.

—ALFRED SISLEY

I like a painting

that makes me want

to stroll into it.

— AUGUSTE RENOIR

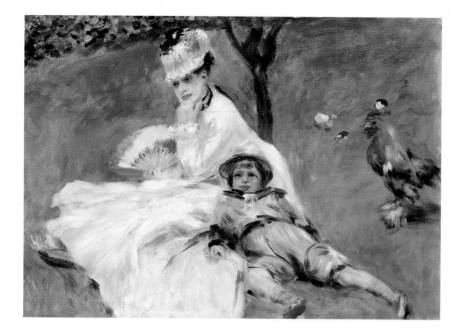

AUGUSTE RENOIR
Madame Monet and Her Son, 1874

During a visit to Monet's house in Argenteuil,
Manet was painting Madame Monet and son
Jean in the garden when Renoir arrived and
asked for a palette as well. This is Renoir's
version of the scene, with just a bit of Monet's
geranium bed in the background. Manet
jokingly noted that it showed Renoir to have
no talent, but Monet kept the painting his
entire life. Manet's wider view included
Monet also, a watering can at his feet.

Right:
CLAUDE MONET
Woman with a Parasol—
Madame Monet and Her Son (detail), 1875

Monet painted his wife Camille and son Jean in a field
near Argenteuil. They were his most frequent models
during their years in Argenteuil, human actors in a
suburban idyll. In these paintings, we see them at
moments of play or relaxation, reading, lunching in
the garden, or walking in lush meadow grass. Monet
originally called this picture *La Promenade*, as if we are
encountering them out for a stroll. Time is arrested,
frozen like the unseen breeze that swirls Camille's
skirts and lifts the wisp of her veil.

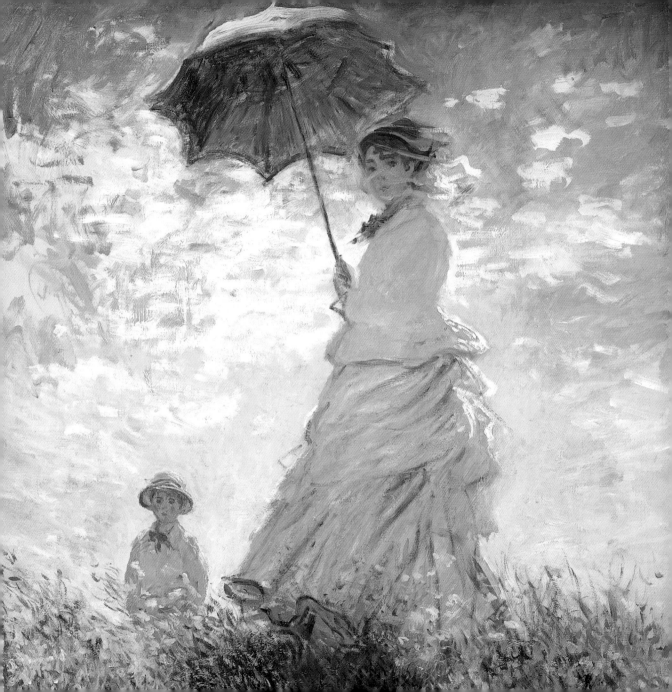

We thought of nothing but having fun and rowing, for all of us . . . regarded rowing as a religion. —Guy de Maupassant, "Mouche"

Excursions to the Seaside and
River Resorts

Like judges or notaries, society ladies or laundresses—like all people in every era—artists have been drawn to the light and moisture-laden air of ocean skies. Perhaps it is natural that *plein-air* painting would, in a sense, begin at the beach. "Do as I did . . . and admire the sea, the light, the blue sky," Eugène Boudin advised a young Claude Monet. Boudin was among the first artists to work directly outdoors, making finished paintings there, not just sketches or studies. As a young man, Monet occasionally

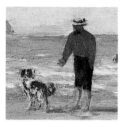 worked alongside Boudin on the Normandy coast, set up in the sun and breeze, right on the sand itself—sometimes the grains still cling to their canvases. Earlier generations of artists had painted these same beaches, producing quaint scenes of fisherfolk and their picturesque ways. Boudin, on the other hand, painted tourists. ❧ The modern tourist was a new phenomenon: a fashionable citizen with time and money to spend. Boudin approached his subjects with a certain ambivalence—"gilded parasites" he once called them, these well-dressed men and women on the beach, strolling with their children and dogs, looking out to sea or tracking the progress of the latest ferry coming ashore. Most of 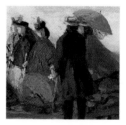 his paintings were bought by the same people, mementos not just of a place they had visited but of their own presence in it. ❧ The notion of a seaside holiday had

originated in Great Britain, and many of the first tourists to towns along the French coast were English. English money helped develop both the resort at Trouville and the railroads connecting Paris with the north. Trouville, *la reine des plages*, offered more than a strip of ocean, with its portable bathhouses and boardwalk. It was a center of fashionable life: the "boulevard des Italiens of the Norman beaches" boasted its own municipal report. There were large hotels and almost all the amusements to be found in Paris: restaurants, theaters, and café-concerts. Performers from the

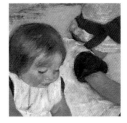

Parisian club Alcazar could be seen during high season. The town's casino offered high-stakes play and games of whist, billiards, and a place to read on an oceanside balcony. Races and regattas, many sponsored by the railroad, crowded the calendar—to say nothing of walks by the sea. ❧ Travel to and from the northern resorts began and ended at Paris' Gare Saint-Lazare—even Offenbach's operetta *La Vie Parisienne* opens with travelers in the crowded station after a Trouville holiday. Train service to many of the smaller suburban towns along the Seine also originated at the Gare Saint-Lazare. These places drew city residents and foreign tourists alike. In the popular Baedeker guide, the pages describing

Paris' *environs* could be detached for easier use. ❧ The train's first stop on the left bank of the river, fewer than ten minutes' ride from the station, was Asnières. Sunday festivals in Asnières were already attracting large crowds in the mid-1850s, as many as six thousand people on a fine day. Facilities expanded to meet the

demands of city vacationers: there were new establishments for swimming and boating, dining and dancing, also circuses and café-concerts, and even a fresh produce market.

Many visitors came only for the day—Sundays particularly—but others built villas and became permanent residents or made extended summer stays. They transformed the once-bucolic place. ❧ Two stops further down was Argenteuil. Here the river widens for several miles upstream—it is more than 200 yards across at Argenteuil itself—and is relatively straight, unobstructed by the islands that occur in so many places. It is perfect for sailing. *Le yachting*, like horse racing, and other

upper-class diversions that appeared in early nineteenth-century France, was an import from England. Wealthy Frenchmen embraced the English sporting tradition—its forms, its etiquette, its philosophy of gentlemen's leisure. There were large numbers of British residents in France. In addition, French aristocrats, who

 had spent years of exile in England, had returned after Waterloo with new tastes and new hobbies. For decades sailing remained a sport of the very rich, but by the 1870s rental boats were widely available and could be enjoyed by middle-class Parisians. ❧

Downstream at Chatou, it was *le rowing* that was the greatest attraction. Men raced in skiffs, pulling hard against the river, or rowed a more leisurely pace in pleasure gigs, often taking a lady to explore quiet inlets and willow-shaded banks. Many women were also dedicated rowers. ❧ The pleasures of Chatou or Argenteuil were not limited to boating enthusiasts. Anyone could stroll the river. The scenes they saw were those the impressionists painted: orange hulls, their reflections skimming the water, crisp sails and the geometry of masts and lines, and the jaunty costumes of weekend sailors—soft felt trousers, a striped jersey or short jacket, a hat of straw or white cloth pulled well down, and linen shoes. As they walked they would note the glint of late afternoon sun on the river, the long shadows striping the promenade Then, there would be dining at an outdoor restaurant along the water's edge, a casual place where the night continued with music and dancing. ❧

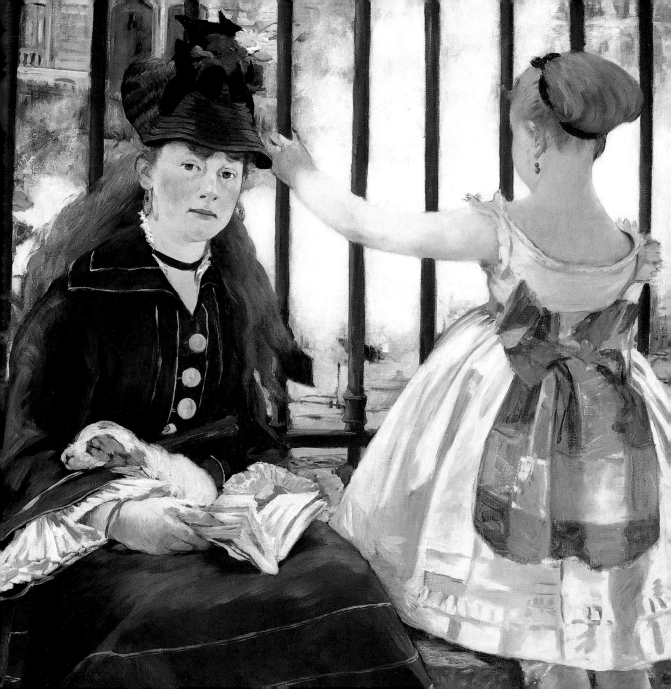

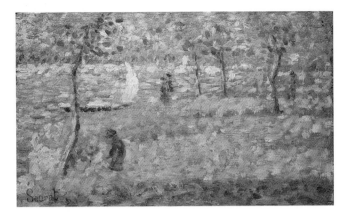

On Sundays . . . it's off to explore Suresnes, Neuilly, the Grande-Jatte . . .

—E. PERIER, *Notes sur la ville d'Asnières*, 1890

Left:

EDOUARD MANET

Gare Saint-Lazare (detail), 1873

Almost unseen behind a fog of steam is the Gare Saint-Lazare. Both day trips to the suburban towns along the Seine and longer excursions to the resorts on the Normandy coast began here, at Paris' busiest train station. Its ambitious bridge, which carried six streets across the rail yard, was itself a familiar landmark.

GEORGES SEURAT

Study for "La Grande Jatte," 1884/1885

Sunday was the only day most workers and their families could take part in the pleasures enjoyed by middle-class Parisians. The close-in park on the Grande Jatte in the Seine, just west of the city, was a favorite destination. It was connected by ferry to the festive eating, music, and boating establishments at Asnières on the north bank. Seurat made a number of studies for his monumental *Sunday Afternoon on the Island of the Grande Jatte*—this one on a cigar box lid. The red-brown "dabs" are not pigment at all, but the wood showing through.

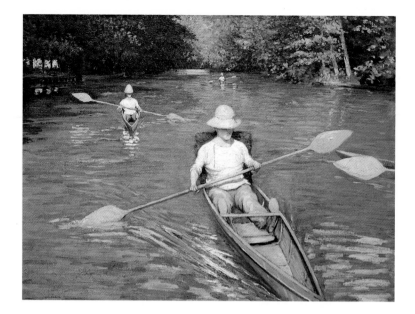

GUSTAVE CAILLEBOTTE
Skiffs, 1877

Caillebotte was an avid sailor and rower, and the
only one of these painters who portrayed the
exertion of sport. He entered both sailing and
rowing contests, sometimes in craft of his own
design. These light-weight, flat-bottomed skiffs
were especially precarious—their French name,
périssoires, comes from a verb meaning "to sink."

Right:
CLAUDE MONET
Argenteuil (detail), c. 1872

For sailing, no place could better Argenteuil. There, the
widening of the Seine produced deeper water and consistent
winds. More than two hundred boats were moored in the
Argenteuil basin in the 1870s. For non-sailors, there were
walks on the town's sun-streaked Promenade, a park that had
been created from an island when a brackish inner channel
was filled. Wines from the vineyards surrounding the town
were modest, but Argenteuil's asparagus, Baedeker's guide
reported, was "justly celebrated."

Sometimes they would gaze out
over the great basin of Argenteuil, where boats
could be seen scudding with their white,
careening sails . . .

—GUY DE MAUPASSANT, "Two Little Soldiers"

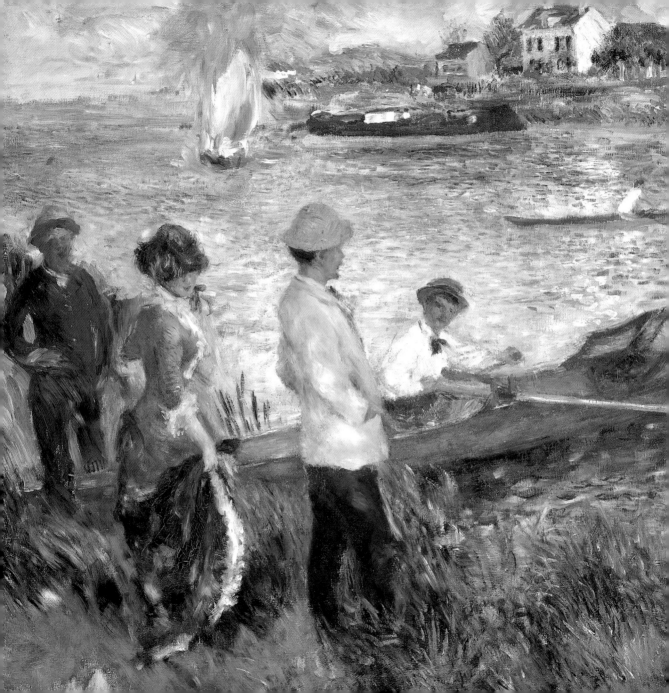

. . . they would spend whole days of discovery, rowing up and down, or lying up in dusky little backwaters, under the willows.

—EMILE ZOLA, *L'Oeuvre*

AUGUSTE RENOIR
Oarsmen at Chatou (detail), 1879

At the rowing center of Chatou, only a few kilometers downstream from Argenteuil, two-person gigs were sometimes raced competitively. But their stability and easy maneuverability made them most popular as pleasure boats, particularly since the rower sat facing his companion, often a lady, who controlled the rudder with ropes.

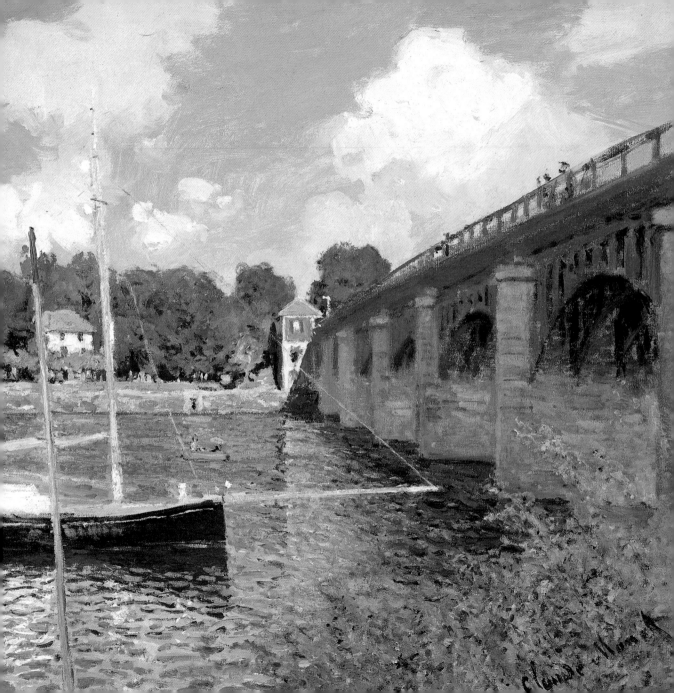

Claude Monet

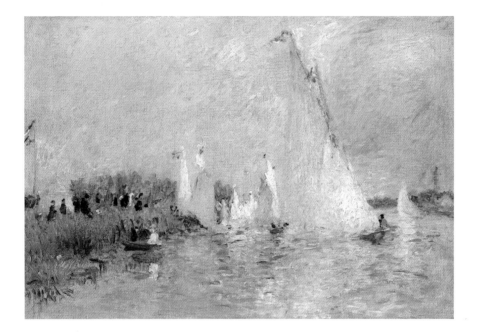

Left:

CLAUDE MONET

The Bridge at Argenteuil (detail), 1874

For almost thirty years, from the early
1860s until 1889, not a single year passed
that Monet did not paint the Seine. While
he was in Argenteuil he produced some
seventy-five river scenes. Here tiny figures
on the new highway bridge pause at the
railing to watch the activity on the river:
sail boats moored, others moving under the
breeze, and a gig rowed at a leisurely pace.

AUGUSTE RENOIR

Regatta at Argenteuil, 1874

From early spring into the fall, at least
two regattas were run each month in
the basin at Argenteuil, drawing
spectators on the banks and in small
boats on the river.

EUGENE BOUDIN

Beach Scene (detail), 1862

When ladies began to appear on the beach,
nude swimming became a thing of the past.
Gustave Flaubert, for one, complained bitterly
at its loss, and was far from impressed by the
look of women's voluminous bathing costumes.
"What a sight! What a hideous sight," he wrote
a friend. Wheeled bathing "machines," which
could be pulled by horses into water waist-
deep, were equipped with a bench, a mirror,
and a place to hang clothes, as well as a tub
of hot water for rinsing the feet.

On the beach a crowd of people were
sitting along the water's edge...

—Guy de Maupassant, "The Model"

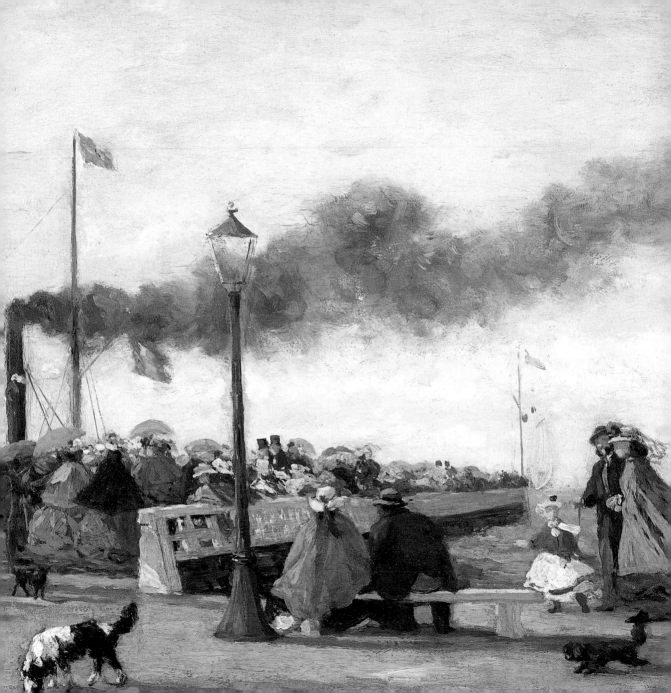

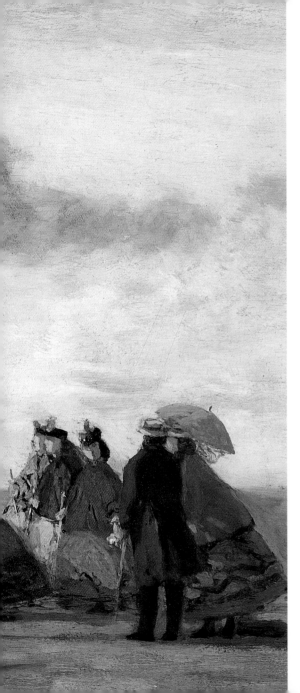

The clouds move in the sky, the tide rises, the breeze plays with flounces and skirts. This is the ocean and you can almost smell the salty fragrance.

—JULES CASTAGNARY on Boudin, *Salon de 1869*

EUGENE BOUDIN
Jetty and Wharf at Trouville (detail), 1863

Boardwalks protected women's skirts. These huge crinolines, which would go out of style before the first impressionist exhibition in 1874, had been known to lift small women off the ground in strong winds. Contributing to the modern feel of Boudin's pictures is his tourists' anonymity. Their fashions, more than their faces, are individualized.

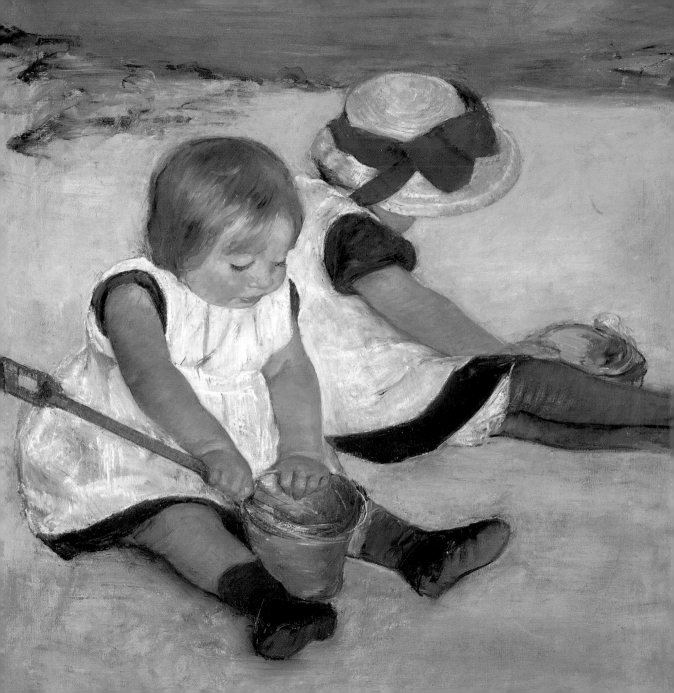

. . . two babies with cheeks like jam,

intent on their games, not heeding the

roaring of the waves.

—JEAN AJALBERT, *La Revue Moderne,* 20 June 1886

MARY CASSATT

Children Playing on the Beach (detail), 1884

This is Mary Cassatt's only beach scene, but
the ocean is simply a vague backdrop to her real
interest—a portrait-like closeup of two children
busy with sand buckets. She probably painted it
while she was in Spain with her ailing mother.
They had gone south to benefit from a warmer
climate. In January Cassatt wrote her brother
Alexander, "We have got to the right spot . . . it
is perfectly delicious here like the most delicious
spring weather."

Of all the flowers,
it is the human
flower that has the
most need of the sun.

—JULES MICHELET

BERTHE MORISOT
The Harbor at Lorient (detail), 1869

Morisot painted this during a
summer visit to her sister Edma in
Brittany—it is Edma who perches
on the harbor parapet in the
protective shade of her parasol.
The beneficial effects of sunlight
were highly touted, but even on
the beach, ladies took great pains
to avoid the sun and the tanned,
weathered complexions of
peasant women that would result.

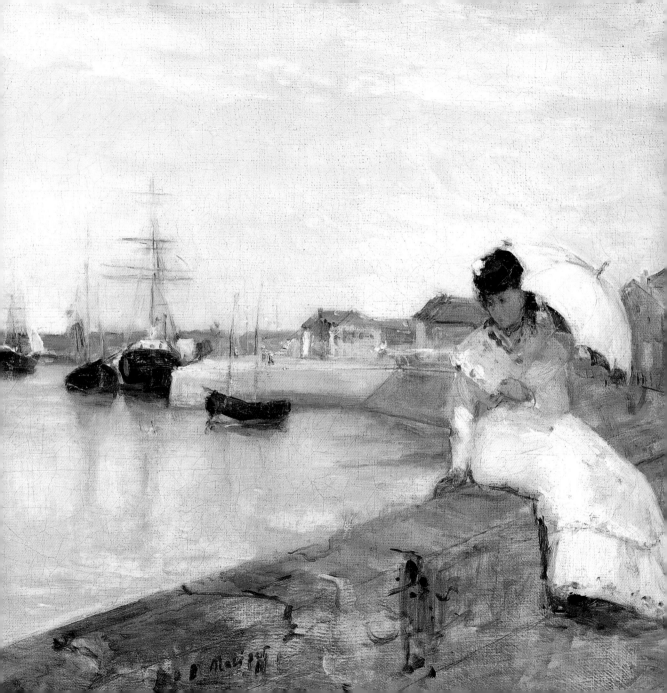

. . . the ideal blue of a southern shore.

—GUY DE MAUPASSANT, *Sur L'Eau*

MARY CASSATT
The Boating Party, 1893/1894

In the 1890s Cassatt began spending
winters at Antibes on the Mediterranean coast.
Under its bright skies and strong light she
experimented with new, harder colors like this
intense blue and citron. She wrote a friend: "For
anyone fond of the sea, & color & light, to say
nothing of boats—this is a wonderful place."

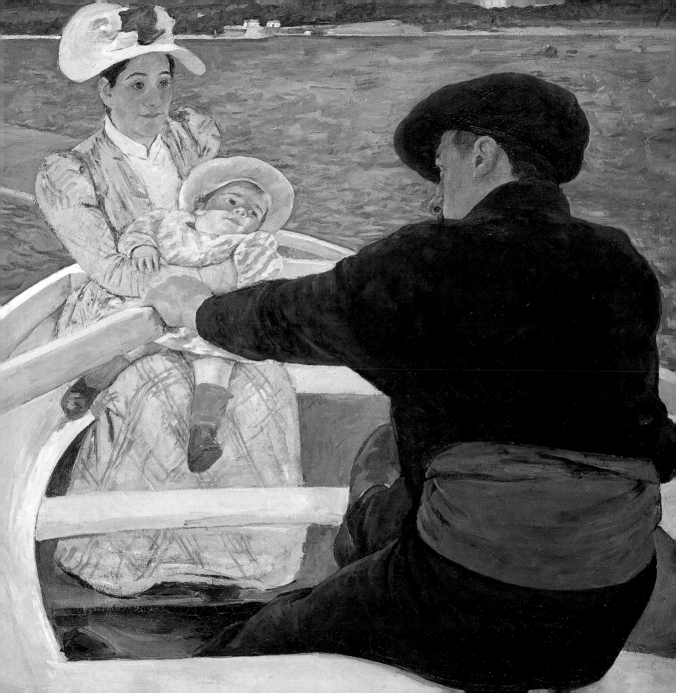

Notes

References are to page numbers.

[8] Quoted by R.L. Herbert, *Impressionism: Art, Leisure, and Parisian Society* (New Haven and London, 1988), 1.

[10] Title of an essay by Walter Benjamin: "Paris, Capital of the Nineteenth Century," in *Reflections*, ed. P. Demetz (New York, 1978).

[10] Ralph Waldo Emerson quoted in W.S. Haine, *The World of the Paris Café* (Baltimore and London, 1996), 1.

[12] Quoted in C. Rearick, *Pleasures of the Belle Epoque: Entertainment and Festivity in Turn-of-the-Century France* (New Haven and London, 1985), 155.

[24] Quoted in F. Cachin, *Manet, 1832–1883*, exh. cat. (Galeries nationales du Grand Palais, Paris, 1983), 349.

[27] Quoted by C.S. Moffett et al., *The New Painting: Impressionism 1874–1886*, exh. cat. (Fine Art Museums of San Francisco, 1986), 141.

[30] A. Delvau on absinthe in 1862, quoted in Herbert, *Impressionism*, 74.

[30] J. de Tinan quoted in Rearick, *Pleasures*, 110.

[32] C. Monet to G. Geffroy, 22 June 1890.

[34] E. Taboureux, *La Vie moderne*, 12 June 1880, quoted in *Monet: A Retrospective*, ed. C.F. Stuckey (New York, 1985), 90.

[40] *Le Jardin: Journal d'horticulture générale*, 1887, quoted in J. Bumpus, *Impressionist Gardens* (New York, 1995), 19.

[43] Monet's stepson J.-P. Hoschedé quoted in *The Impressionists at First Hand*, ed. B. Denvir (London, 1987), 151.

[43] Monet quoted in Bumpus, *Impressionist Gardens*, no. 37.

[44] Letter from Pissarro to his son Lucien, 1 March 1884, in *Camille Pissarro: Letters to His Son Lucien*, ed. J. Rewald with the assistance of L. Pissarro (rpt. New York, 1995), 58.

[44] J. Castagnary on Pissarro's cabbages quoted in J. Rewald, *Camille Pissarro* (New York, 1989), 28.

[48] A. Sisley quoted in *Impressionists at First Hand*, 122.

[49] A. Renoir to A. André quoted in J. House, "Renoir's Worlds," in *Renoir*, exh. cat. (Hayward Gallery, London, 1985), 14.

[54] Recalled in a letter from Monet to G. Jean-Aubry, quoted by V. Hamilton, *Boudin at Trouville*, exh. cat. (Glasgow Museums, 1992), 44.

[55] Trouville, *Guide annuaire*, 1868, quoted by Herbert, *Impressionism*, 294.

[59] Quoted in R. Thomson, *Seurat* (Oxford, 1985), 117.

[67] Quoted in Hamiliton, *Boudin at Trouville*, 55.

[69] Quoted in Hamiliton, *Boudin at Trouville*, 59.

[71] J. Ajalbert quoted in Moffett el al., *New Painting*, 451.

[71] 5 January 1884, from Fonda de Europa, Tarragona, in *Cassatt and Her Circle: Selected Letters*, ed. N.M. Mathews (New York, 1984), 177.

[72] Quoted in Hamiliton, *Boudin at Trouville*, 53.

[74] Letter to Eugenie Heller, 30 January 1894, from Villa "La Cigaronne," in *Cassatt and Her Circle*, 252.

For Further Reading

R.L. Herbert, *Impressionism: Art, Leisure, and Parisian Society* (New Haven and London, 1988).

L.E. Rathbone, et al., *Impressionists on the Seine*, exh. cat. (Phillips Collection, Washington, D.C., 1996).

C. Rearick, *Pleasures of the Belle Epoque: Entertainment and Festivity in Turn-of-the-Century France* (New Haven and London, 1985).

B.S. Shapiro, with the assistance of A.E. Havinga, *Pleasures of Paris: Daumier to Picasso*, exh. cat. (Museum of Fine Arts, Boston, 1991).

All of the illustrated works of art are from the permanent collections of the National Gallery of Art, Washington.

Pierre Bonnard (1867–1947)
Table Set in a Garden, c. 1908
Oil on paper mounted on canvas
49.5 × 64.7 cm
Ailsa Mellon Bruce Collection
1970.17.8

Eugène Boudin (1824–1898)
Beach Scene, 1862
Oil on wood, 31.2 × 47.5 cm
Collection of Mr. and Mrs. Paul Mellon
1983.1.13

Eugène Boudin (1824–1898)
Jetty and Wharf at Trouville, 1863
Oil on wood, 34.6 × 57.8 cm
Collection of Mr. and Mrs. Paul Mellon
1983.1.9

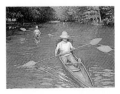

Gustave Caillebotte (1848–1894)
Skiffs, 1877
Oil on canvas, 88.9 × 116.2 cm
Collection of Mr. and Mrs. Paul Mellon
1985.64.6

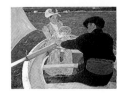

Mary Cassatt (1844–1926)
The Boating Party, 1893/1894
Oil on canvas, 90 × 117.3 cm
Chester Dale Collection
1963.10.94

Mary Cassatt (1844–1926)
Children Playing on the Beach, 1884
Oil on canvas, 97.4 × 74.2 cm
Ailsa Mellon Bruce Collection
1970.17.19

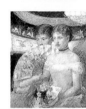

Mary Cassatt (1844–1926)
The Loge, 1882
Oil on canvas, 79.8 × 63.8 cm
Chester Dale Collection
1963.10.96

Edgar Degas (1834–1917)
Dancers Backstage, 1876/1883
Oil on canvas, 24.2 × 18.8 cm
Ailsa Mellon Bruce Collection
1970.17.25

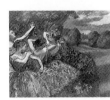

Edgar Degas (1834–1917)
Four Dancers, c. 1899
Oil on canvas, 151.1 × 180.2 cm
Chester Dale Collection
1963.10.122

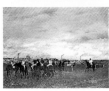

Edgar Degas (1834–1917)
The Races, before 1873
Oil on wood, 26.5 × 35 cm
Widener Collection
1942.9.18

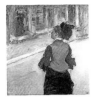

Edgar Degas (1834–1917)
Woman Viewed from Behind
Oil on canvas, 81.3 × 75.6 cm
Collection of Mr. and Mrs. Paul Mellon
1985.64.11

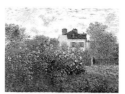

Claude Monet (1840–1926)
The Artist's Garden in Argenteuil
(A Corner of the Garden with Dahlias), 1873
Oil on canvas, 61 × 82.5 cm
Gift (Partial and Promised) of
Janice H. Levin, in Honor of the 50th
Anniversary of the National Gallery of Art
1991.27.1

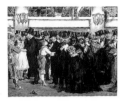

Edouard Manet (1832–1883)
Ball at the Opera, 1873
Oil on canvas, 59 × 72.5 cm
Gift of Mrs. Horace Havemeyer
in memory of her mother-in-law,
Louisine W. Havemeyer
1982.75.1

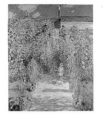

Claude Monet (1840–1926)
The Artist's Garden at Vétheuil, 1880
Oil on canvas, 151.5 × 121 cm
Ailsa Mellon Bruce Collection
1970.17.45

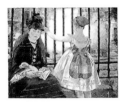

Edouard Manet (1832–1883)
Gare Saint-Lazare, 1873
Oil on canvas, 93.3 × 111.5 cm
Gift of Horace Havemeyer
in memory of his mother,
Louisine W. Havemeyer
1956.10.1

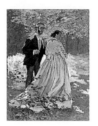

Claude Monet (1840–1926)
Bazille and Camille (Study for
"Déjeuner sur l'Herbe"), 1865
Oil on canvas, 93 × 68.9 cm
Ailsa Mellon Bruce Collection
1970.17.41

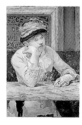

Edouard Manet (1832–1883)
The Plum, c. 1877
Oil on canvas, 73.6 × 50.2 cm
Collection of Mr. and Mrs. Paul Mellon
1971.85.1

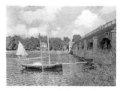

Claude Monet (1840–1926)
The Bridge at Argenteuil, 1874
Oil on canvas, 60 × 79.7 cm
Collection of Mr. and Mrs. Paul Mellon
1983.1.24

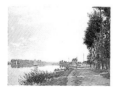

Claude Monet (1840–1926)
Argenteuil, c. 1872
Oil on canvas, 50.4 × 65.2 cm
Ailsa Mellon Bruce Collection
1970.17.42

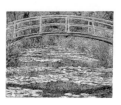

Claude Monet (1840–1926)
The Japanese Footbridge, 1899
Oil on canvas, 81.3 × 101.6 cm
Gift of Victoria Nebeker Coberly, in
memory of her son John W. Mudd, and
Walter H. and Leonore Annenberg
1992.9.1

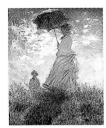

Claude Monet (1840–1926)
Woman with a Parasol—
Madame Monet and Her Son, 1875
Oil on canvas, 100 × 81 cm
Collection of Mr. and Mrs. Paul Mellon
1983.1.29

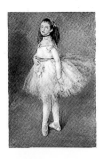

Auguste Renoir (1841–1919)
The Dancer, 1874
Oil on canvas, 142.5 × 94.5 cm
Widener Collection
1942.9.72

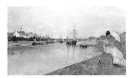

Berthe Morisot (1841–1895)
The Harbor at Lorient, 1869
Oil on canvas, 43.5 × 73 cm
Ailsa Mellon Bruce Collection
1970.17.48

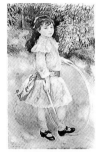

Auguste Renoir (1841–1919)
Girl with a Hoop, 1885
Oil on canvas, 125.7 × 76.6 cm
Chester Dale Collection
1963.10.58

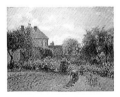

Camille Pissarro (1830–1903)
The Artist's Garden at Eragny, 1898
Oil on canvas, 73.4 × 92.1 cm
Ailsa Mellon Bruce Collection
1970.17.54

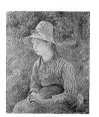

Camille Pissarro (1830–1903)
Peasant Girl with a Straw Hat, 1881
Oil on canvas, 73.4 × 59.6 cm
Ailsa Mellon Bruce Collection
1970.17.52

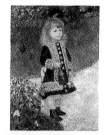

Auguste Renoir (1841–1919)
A Girl with a Watering Can, 1876
Oil on canvas, 100.3 × 73.2 cm
Chester Dale Collection
1963.10.206

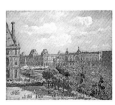

Camille Pissarro (1830–1903)
Place du Carrousel, Paris, 1900
Oil on canvas, 54.9 × 65.4 cm
Ailsa Mellon Bruce Collection
1970.17.55

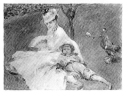

Auguste Renoir (1841–1919)
Madame Monet and Her Son, 1874
Oil on canvas, 50.4 × 68 cm
Ailsa Mellon Bruce Collection
1970.17.60

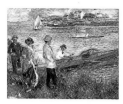

Auguste Renoir (1841–1919)
Oarsmen at Chatou, 1879
Oil on canvas, 81.2 × 100.2 cm
Gift of Sam A. Lewisohn
1951.5.2

Alfred Sisley (1839–1899)
Meadow, 1875
Oil on canvas, 54.9 × 73 cm
Ailsa Mellon Bruce Collection
1970.17.83

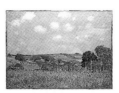

Auguste Renoir (1841–1919)
Picking Flowers, 1875
Oil on canvas, 54.3 × 65.2 cm
Ailsa Mellon Bruce Collection
1970.17.61

Alfred Sisley (1839–1899)
The Road in the Woods, 1879
Oil on canvas, 46.3 × 55.8 cm
Chester Dale Collection
1963.10.215

Auguste Renoir (1841–1919)
Pont Neuf, Paris, 1872
Oil on canvas, 75.3 × 93.7 cm
Ailsa Mellon Bruce Collection
1970.17.58

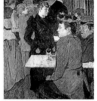

Henri de Toulouse-Lautrec (1864–1901)
A Corner of the Moulin de la Galette, 1892
Oil on cardboard, 100 × 89.2 cm
Chester Dale Collection
1963.10.67

Auguste Renoir (1841–1919)
Regatta at Argenteuil, 1874
Oil on canvas, 32.4 × 45.6 cm
Ailsa Mellon Bruce Collection
1970.17.59

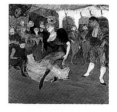

Henri de Toulouse-Lautrec (1864–1901)
*Marcelle Lender Dancing the Bolero
in "Chilpéric,"* 1895–1896
Oil on canvas, 145 × 149 cm
Gift (Partial and Promised) of
Betsey Cushing Whitney in honor of
John Hay Whitney, for the 50th
Anniversary of the National Gallery of Art
1990.127.1

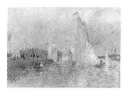

Georges Seurat (1859–1891)
Study for "La Grande Jatte," 1884/1885
Oil on wood, 15.9 × 25 cm
Ailsa Mellon Bruce Collection
1970.17.81

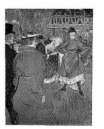

Henri de Toulouse-Lautrec (1864–1901)
Quadrille at the Moulin Rouge, 1892
Oil on cardboard, 80.1 × 60.5 cm
Chester Dale Collection
1963.10.221

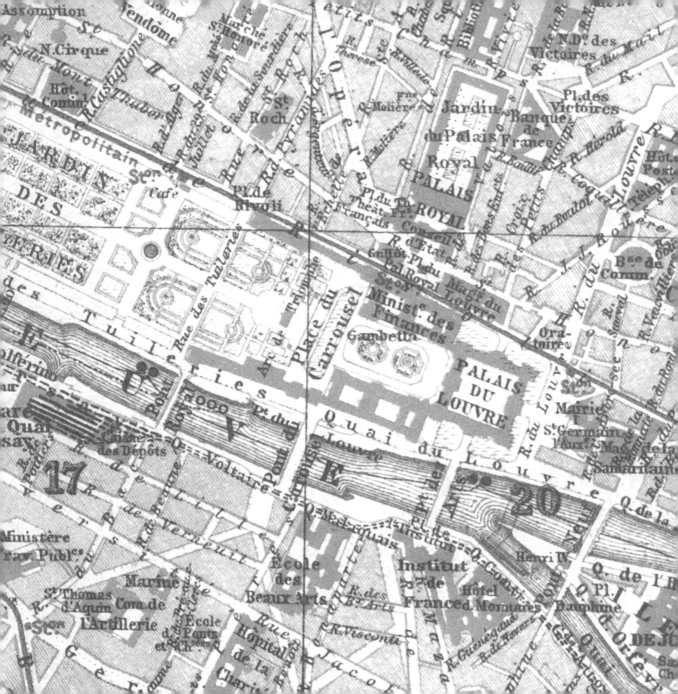